Two Plays:

What is the Answer, Sir Theatre?

&

the handmedownjacket

m.p. hanck

Copyright © 2016 m.p. hanck

All rights reserved.

ISBN-13: 978-1547172207

ISBN-10: 1547172207

DEDICATION

To the Ashland University Theatre Department
for being the testing grounds for this sort of thing.

&

To Daniel Marlett, the original Professor of Knowledge and Director of the
original handmedownjacket, a good friend.

CONTENTS

	Preface	i
1	What is the Answer, Sir Theatre?	1
2	the handmedownjacket	27

PREFACE

In college, I learned to read. By this, I mean that I learned to appreciate reading. Prior to that time, I was able to pass classes and achieve excellent grades by merely listening to my teachers. During my first semester in college, however, a professor, Susan Brown, made it a point to impress upon me the importance of reading. She relentlessly drilled into my mind the value of reading in addition to listening to lectures. After that class with Professor Brown, I began reading voluminously. I devoured nearly every play on the Theatre Department's Suggested Reading List. After completing every play of interest on their list, I branched out into other subjects that captivated me. Yet, time and time again, I found myself, throughout the rest of my college career, returning to the Theater of the Absurd. Though I had not yet been fortunate enough to see any absurdist plays performed, I found the style, themes, philosophical underpinnings, and social commentary within absurdist plays to be complex, dynamic, refreshing, and precise in unexpected ways. Living in the time after the advent of the internet, I was fortunate in being able to acquire absurdist plays that had long been out of print in the English language. I was amazed by the sheer number of plays that, were it not for used book stores and online retailers, could be lost to the English-reading population. In my mad quest to collect and preserve as many absurdist plays as I could, I began consuming more and more of them. Eventually, toward the end of my time as a college student, I realized that, instead of only collecting and preserving these plays, I should continue to develop their style, themes, philosophical underpinnings, and social commentary in the context of the twenty-first century. I tried writing dozens of plays. Most of them fell flat, mimicking only 1) the manic and nonsensical scenes of some absurdist plays and 2) the bitter, biting moments of social commentary which other absurdist plays provide, which, in my honest opinion now, would only have made for a form of cringe-worthy mass torture for audiences. The two plays in this volume, however, have withstood eight years of their creator's judgment, and while they still have quite a bit of nonsense and bitter, biting moments of social commentary within them, I believe that they are worth having in existence, especially after some recent editing. So, as with the many other absurdist plays that I have collected, preserved, and protected, I will, through the gift of self-publishing, now do the same with these two plays, *What is the Answer, Sir Theatre?* and *the handmedownjacket*. May they be merciful towards you and not abuse your senses too much.

WHAT IS THE ANSWER, SIR THEATRE?

<u>The Unfortunate Cast of Characters</u>

Student 1	an student who is adept
Student 2	a student who is struggling
Student 3	a student who does not care
Sir Theatre	a person out of time and place
Professor of Knowledge	the professor of all knowledge, wears a long black academic gown every day

<u>The Setting</u>

A classroom with four student desks and one large blackboard

(The curtain opens. There are four desks and papers with giant letters on the floor. Student 1 is sitting in the first desk. Student 2 is sitting in the second desk. Student 3 is sitting in the third desk. Sir Theatre enters the classroom, confused as to how he arrived here in this time and place. Student 1, Student 2, and Student 3 are all dressed in the same manner. Sir Theatre is an individual; he is dressed in the wrong time period. Next to the first desk, there is a large blackboard with the words "What is Knowledge" written on it. Sir Theatre looks at the blackboard, wondering what it means. Student 1 and Student 2 glare at Sir Theatre. Student 3 simply does not care. Under the pressure of their gaze, Sir Theatre decides to sit in the fourth desk. Professor of Knowledge enters.)

[DEEDUCATION]

Student 1
Good morning, Professor of Knowledge!

Student 2
Will this be long today, Professor of Knowledge?

Student 3
I don't want to learn anything, Professor of Knowledge!

(There is a long pause. Everyone looks at Sir Theatre expectantly.)

Sir Theatre
Oh...

Professor of Knowledge
(Lecturing)
You have to learn to take a stand while there are no negative consequences.

Sir Theatre
...What?

Professor of Knowledge
You have to learn to take chances while you still can - or you'll never find the answer.

Sir Theatre
I still don't understand.

Professor of Knowledge
Your response. You had no response.

Sir Theatre
Well... I'm sorry. I just didn't know that I had to say something.

Professor of Knowledge
You should have known by the set of three greetings that took place in response to my entrance. It was supposed to be four, a set of four.

Sir Theatre
Excuse me, but that really wasn't a set. A real set.

Professor of Knowledge
Yes, it was. You see, a set is a group of things that are the same, that are identical, and they were all greetings;

therefore, they, all together, formed a set.

Sir Theatre
But they weren't identical at all.

Professor of Knowledge
And why not?

Sir Theatre
Because they were all different.

Professor of Knowledge
They were all greetings though.

Sir Theatre
But they weren't the same greeting.

Professor of Knowledge
Ah, but you do admit that they were all greetings though!

Sir Theatre
Well, actually, the first one was a greeting. But the second one was a question, and the third one was a complaint.

Professor of Knowledge
 (With a grave frown)
Hmmm...
 (There is a short pause)
Each one is different. You're right about that. But they were all greetings as well, even if a question, even if a complaint, which means that they were all the same, even if different. Sameness trumps difference.

Sir Theatre
(Rising to leave)
Fine. Believe that if you would like, but I'm not going to sit here and listen to this sophistry.
(There is a short pause)
...I don't even know how I got here!

Professor of Knowledge
(Pulling out a sharp scalpel)
What?

Sir Theatre
What? Wait, what are you doing with that? I thought you were supposed to be some sort of professor.

Professor of Knowledge
(Blocking the exit; in a darker mood)
I am a professor, the Professor of Knowledge. It is my job to...
(He searches for the right phrase)
...probe the human mind, even into its deepest and darkest recesses.
(He brushes off his academic gown; in a lighter mood)
It's an endowed chair. Of course.
(Returning to his former, darker mood)
But what am I doing? Nothing... Teaching class...
(There is a short pause)
What are you possibly talking about...?

Sir Theatre
You can't do this.

Professor of Knowledge
(Slowly)
You're here for a reason. Aren't you?

Well, you must be if you are here. So why don't you simply sit down – and learn. And then, afterwards, you can leave… Ok…? Ok.

Sir Theatre
 (Sitting down)
This is wrong…

Professor of Knowledge
 (Putting the scalpel away and moving away from the exit)
The problem is that you're thinking far too subjectively about all of this.

Sir Theatre
I'm sorry. I just think that everything's subjective.

Professor of Knowledge
Really?

Sir Theatre
Or perhaps contextual instead. Everything is very contextual. Everything is very subjected to the context.

Professor of Knowledge
Well, we're going to have to fix that. Objectivity is key. Everyone knows that.

Sir Theatre
I don't understand.

Professor of Knowledge
 (Releasing a sigh of exasperation)
My boy, I am a professor.

Student 1
And oh boy, is he really!

Sir Theatre
I know that; however-

Professor of Knowledge
(Interrupting him)
I know that you know that. I am a professor.

Student 2
(Taking notes)
A - professor.

Sir Theatre
I know that you know that I know that. But I don't know why I am here and why you are insisting on objectivity and on your professorship.

Professor of Knowledge
You don't know that?

Sir Theatre
No.

Professor of Knowledge
I know.

Sir Theatre
Wait... What?

Professor of Knowledge
(Releasing another exasperated sigh)
That was a method of conveying to you that I know that you know that I know that you know that I do indeed know. I am a professor. I know. I will teach you, and you will know. I will know that you know because I know that I am a professor and know how to teach you objectively. Objectively, I will teach

you what I know so that you will know what I
know with everything that I know which I
know you will know by the end of this class
on knowing. Any questions?

Student 3
I want to drink beer and have lots of sex.

Student 1
That's foolish! You should spend your time
doing wiser things. Like studying. So you
can have something concrete beneath your
feet.

Professor of Knowledge
You see, knowledge makes you strong.
Knowledge is forever. Knowledge is the
foundation on which you can make your stand.

Sir Theatre
 (Conceding a bit now)
Well, you know, almost everything is good…in
moderation.

Professor of Knowledge
Hmmm…
 (There is a short pause)
Perhaps it is time for another lesson.
 (Taking apart the word in the air)
Moderation. Root word – moderate. Moderate
– to lessen.

Student 1
I see!

Student 3
 (As though learning from Student 1)
I see!

Sir Theatre
(Scoffing)
What kind of lesson is this?

Professor of Knowledge
Good question!

Sir Theatre
Why is that a good question? It's an awful question! I shouldn't even have to ask such a question! And, to be honest, even if I accept that you're a professor, I still don't know why it is that I'm here!

Professor of Knowledge
Ah, and here is where it all comes full circle! To find and learn the lesson so that your knowledge won't lessen!

Sir Theatre
Can I have clearer directions, please?

Student 3
(Thinking he has learned how to make interjections in this play though he is mistaken)
Don't make me laugh. Because I like to do that. I can laugh.

Professor of Knowledge
Clearer directions? Could it be any clearer?

Sir Theatre
Couldn't you explain it?

Professor of Knowledge
Do you want me to explain it?

Sir Theatre

Yes.

Professor of Knowledge

Oh.

 (There is a grand pause. The pause is so long as to become awkward. It is long enough to cause Sir Theatre to wonder whether or not he should say something else before Professor of Knowledge begins his explanation. The pressure of the silence finally causes Sir Theatre to begin another short reply or interjection, but just as he is opening his mouth to begin that reply or interjection, Professor of Knowledge responds again.)

Ok.

 (He goes up to the blackboard. He writes on the blackboard as he talks)

Now don't interrupt me until I finish. I hate to be interrupted. Interruptions throw me off course, and even worse, they throw the entire class off course, which makes my work harder because my job is to instruct the class and keep them on an objective course. What course? A course towards knowledge. That's why I teach this course and many other such courses like it. In fact, that explains the word course, for those of you who do not already know that. As I was saying, I work hard, and I try to work harder, but I already work hard enough, so please don't interrupt. Any questions?

 (Student 3's hand is raised. Professor of Knowledge overlooks it.)

Good. Great. Wonderful. So, to go back and stay on course, to moderate is to lessen. Therefore you must lessen, or

subtract, from moderate, but what are you subtracting? You're lessening, right? But lessening, subtracting, by what? If you go back to the original problem that we were presented with, you will see that we began with moderation; therefore, you must subtract by e and add i-o-n to balance the equation, to get back to the base of things, to get towards the root of it all, the original problem. However, you still haven't found the answer, the end, and in that, there is something of the answer itself. Since we are going by roots in trying to get to *the* roots, we must take "found" back to its roots. Find is obviously the root of found, which makes sense as we are indeed trying to find the answer. If you don't know that then you're simply in the wrong classroom.
 (Sir Theatre rises to leave)
Sit down, and don't interrupt!
 (Sir Theatre sits down)
Now where was I? Ah, yes! We must find the answer! As we have discussed, lessons are used to find answers. You can also use discussions, stories, readings, and so forth, but using a lesson works perfectly well in this circumstance and we need not take each one of those methods back to their individual roots; we'll have plenty of roots to sort out as it is in trying to get back to *the* root, *the* answer. After all, if you use another method, you're creating a whole different problem, Methodism, but we'll discuss that at a later date. So! Back to find, the root of found! To find the answer, we use a lesson. Lessons simplify knowledge. They are simply summaries. A deeper body of knowledge lies beyond each

lesson. And what does that mean? It means that lessons lessen knowledge. They sharpen them to a point. This makes it easier to inject intellect into the brain, to reach those deeper and darker recesses in the human mind. Learning is therefore lessening. Lessening is a way to learn. A complete circle has thus been formed around all knowledge with one simple equation. The real problem lies here, because the fact that we have gone in a circle means that the answer has been surrounded but not found. We did not find it, though we got close. The answer is… It could be anything! Who knows what!
 (He circles the "What" of "What is Knowledge" and moves away from the blackboard)

Student 2
 (Taking notes)
Found – find – lesson – lessen – answer – what.

Sir Theatre
 (Trying hard to discern the logic)
Can you define that so I can find the lesson so that my knowledge won't be lessened?

Student 3
I can laugh!

Student 1
You're interrupting!

Student 3
I can interrupt!

Professor of Knowledge
(Trying hard to discern the logic)
Define to find and learn the lesson so that your knowledge won't be lessened?

Sir Theatre
I don't understand! This is all so dreadfully confusing-
 (There is a very short pause)
And incredibly stupid!

Professor of Knowledge
Ahem! Define to find and learn the lesson so that your knowledge won't be lessened?!

Sir Theatre
What kind of knowledge is this? It's just a bunch of mumbo-jumbo! A sack of hocus-pocus!

Student 1
In other words?

Sir Theatre
A sham!

Professor of Knowledge/Student 1/Student 2
 (Gasping)
A sham?!

Sir Theatre
A joke!

Professor of Knowledge/Student 1/Student 2
 (Gasping)
A joke?!

[REEDUCATION]

Sir Theatre
I believe.

Professor of Knowledge
 (Caught off guard)
...What?

Sir Theatre
I simply said, "I believe."

Professor of Knowledge
In what?

Sir Theatre
What?

Student 1
You believe in "what"?

Student 2
 (Taking notes)
Believe – in – what.

Professor of Knowledge
Then you believe in "what."

Student 3
I can move around a lot!

Sir Theatre
What is what?

Professor of Knowledge
 (Having an epiphany)
Indeed! The What!

Student 1
How insightful!

Sir Theatre
What do you mean?

Professor of Knowledge
What do you mean!

Student 2
 (Taking notes)
What - do - you - mean.

Student 1
That's brilliant!

Professor of Knowledge
So what now?

Sir Theatre
 (With everyone leaning in towards him)
I - I don't know what!

Professor of Knowledge
Tell us more!
 (There is a pause)
Well, come on! Out with it! Just tell us more! Come on, boy!

Student 3
I can scratch my armpits!

Sir Theatre
I wish I could scratch my armpits...

Student 1
What?

Student 2
What?

Professor of Knowledge
What?

Sir Theatre
I don't know what!

Professor of Knowledge
You already said that! Now we want to know more! More! Come on, boy!

Sir Theatre
What more do you want to know?

Student 3
I can eat bananas!

Professor of Knowledge
(To Sir Theatre)
What was that?

Sir Theatre
I don't know! Whatever you want it to be!

Professor of Knowledge
(Turning to Student 1)
Whatever we want "whatever you want it to be" to be…

Student 1
(To Professor of Knowledge)
A puzzle!

Professor of Knowledge
(To Student 1)
It is!

Sir Theatre
What is it?

Professor of Knowledge/Student 1/Student 2
Ahh! I see…

Student 3
I can fling poo!

Professor of Knowledge
It could be…
 (There is a short pause)
I don't know whatever you want it to be…

Student 1
Or it could be…
 (There is a short pause)
I don't know whatever. You want it to be…
 (There is a short pause)
But then how would it end?

Student 2
I don't know what to write!

Student 1
Could it be…
 (There is a short pause)
A doughnut?

Sir Theatre
What doughnut?

Professor of Knowledge & Student 1
Exactly! The circle again!

Professor of Knowledge
Which-

Student 1
-means-

Professor of Knowledge
-that-

Student 1
-the-

Professor of Knowledge
-answer-

Student 1
-is-
 (There is an unbearably suspenseful
 pause)

Sir Theatre
What?

Professor of Knowledge & Student 1
Exactly!

Student 2
We went too fast! I didn't get to write it down!

Professor of Knowledge
 (Pointing to the notes)
All of it should be right there. It should all be right there!

Student 2
But all I see are a bunch of pin-points, hacks, and slashes pointing back up at me!

Sir Theatre
 (Trying to look at the notes)
But what did you write?

Professor of Knowledge
What did you write! Yes! Yes, that's it!

What did you write!
 (He tackles Student 2. Student 2 is knocked unconscious. He picks up the notes.)

Student 1
Good job, Professor of Knowledge!

Professor of Knowledge
 (Reading the notes)
A professor find lesson lessen believe in what – what do you mean...
 (There is a short pause. Professor of Knowledge throws away the notes in frustration.)
Rubbish!
 (Kicking Student 2 in the stomach)
You've failed! "F"! "F" for futile!
 (Giving Student 2 the middle finger)
"F" you!

Student 1
I'm still the best student, Professor of Knowledge.
 (Sir Theatre looks over at Student 1 and pauses)

Sir Theatre
So what?

Professor of Knowledge
So what!

Student 1
And we thought that you were stupid! You're almost as smart as I am!
 (After saying this, Student 1's admiration of Sir Theatre slowly starts to turn into envy)

Sir Theatre
I don't know about that.

Professor of Knowledge
That's because we are discussing what.

Sir Theatre
But what are we discussing?

Professor of Knowledge
 (Kissing Sir Theatre's head)
Bless that head of yours, boy! Bless that head!
 (He starts drawing random shapes and figures on the blackboard in order to figure out the answer)

Student 1
I could have thought of that...
 (Student 1 joins Professor of Knowledge at the blackboard)

Student 3
 (Underneath the other dialogue)
I can make noises!

Sir Theatre
 (Aside)
Why am I here? Who are these people? And what the hell is wrong with them?

Student 3
Some from my mouth and some from my butt!

Sir Theatre
Do you really have to be so coarse?

Professor of Knowledge
(Still working at the blackboard, responding without turning around)
I teach this course and many other such courses like it.

Student 3
I can make mush out of bananas. Hee-hee-hee.
(Student 3 emits a series of monkey-like grunts. He is slowly transformed into a monkey. By the end of his transformation, he has made a complete spectacle in and of himself.)

Sir Theatre
(Aside)
What is he thinking...?

Professor of Knowledge
(He stops drawing on the blackboard suddenly)
What is he thinking! Another piece of the puzzle!
(He tackles Student 3. Student 3 is knocked unconscious. Professor of Knowledge's scalpel reappears, and with the scalpel and brute force, he rips out Student 3's brain.)
This aught to be useful for something.

Student 1
But what?

Sir Theatre
Yeah - what?

Professor of Knowledge
(To Sir Theatre)
You're a genius!

Student 1
Damn it! I was about to say "what"!

Sir Theatre
But… You did.

Student 1
No, I didn't say it right.

Sir Theatre
(Jovially)
You don't know what you're talking about.

Student 1
That - that's the final insult that I'm going to take from you!

Sir Theatre
Huh?
　　(There is a short pause)
Aw, come on. You know I didn't mean to hurt your feelings, don't you? It's okay. Really. Look, maybe - maybe I don't know what I'm talking about.

Professor of Knowledge
(To Sir Theatre)
That's nonsense! Total nonsense! You're the best student I've ever had. The absolute best student ever!
　　(Looking over the brain)
But I wonder where the answer lies.

[RECOMPOSITION]

Sir Theatre
(To Professor of Knowledge)
I don't know. Probably deep within. Don't you think?

Professor of Knowledge
(To himself)
It's so unfathomably unfathomable.

Student 1
(To Sir Theatre)
I'll never forgive you.

Professor of Knowledge
(To himself)
I'll never reach it!

Sir Theatre
(To Professor of Knowledge)
Unless you break it open.

Student 1
(To Sir Theatre)
I'm smarter than you are.

Professor of Knowledge
(To Sir Theatre)
But that would ruin it.

Student 1
(To Sir Theatre)
I'll ruin you.

Sir Theatre
(To Professor of Knowledge)
It's already ruined.

Student 1
(To Sir Theatre)
One of these days, I'm going to kill you.

Professor of Knowledge
(Pulling the brain apart; to himself)
What. What. What.

Student 1
(To Sir Theatre)
Just who do you think you are anyway?

Sir Theatre
(To Professor of Knowledge)
That's what I want to know.

Professor of Knowledge
(To himself)
I told you. I am a professor.

Sir Theatre
(To Professor of Knowledge)
No.
 (Motioning towards the brain)
I meant – What. What. What.

Student 1
(To Sir Theatre)
I swear that I'm going to kill you.

Professor of Knowledge
(His hand has found something inside of the brain)
The What!
 (He pulls a mirror out of the brain)
But what?

Sir Theatre
(Looking into the mirror -- horrified)
Oh...

Student 1
(Looking into the mirror -- horrified)
Oh...

Professor of Knowledge
(Looking into the mirror -- horrified)
Oh...
(There is a very uneasy silence)

Student 1
But-

Sir Theatre
-what-

Professor of Knowledge
-is-

Sir Theatre
-what?

[DECOMPOSITION]

(Now that they have been stupefied by the What, they are becoming increasingly terrified. Their fear forces them to move away from each other. The awful looks on their faces increase as they move further away. Then, suddenly, papers with enormous letters and bloodstains fall from the ceiling. They try to avoid touching the strange papers. They are animals trapped in a cage. They can no longer use words. Instead, they can only make

grunts and moans. Student 1 tries to escape the classroom. Student 1, instead of escaping, however, is bombarded by papers and shrivels up into nothing. The papers continue to fall on Student 1 until Student 1's body is completely covered. Sir Theatre and Professor of Knowledge have now created separate, little dwellings for themselves out of the available desks. Professor of Knowledge is able to reach out and grab one of Student 2's limbs. He pulls Student 2's body into his lair. He starts eating Student 2. It has become apparent that Sir Theatre, Professor of Knowledge, and the outside world are separated and trapped forever. The curtain closes. Blackout. There is no curtain call.)

THE END

* Playwright's Note: If taking out Student 3's brain onstage appears to be an impossible feat for the production because of space or other issues, Professor of Knowledge can have Student 1 drag Student 3's body offstage and return momentarily with Student 3's brain on a veiled platter, which can then be unveiled for dramatic effect.

the handmedownjacket

The Cast of Characters

Mitchell	Dawn's son. Shore's brother. An addict. Lost.
Shore	Mitchell's sister. Dawn's daughter. Troubled.
Dawn	Mitchell and Shore's mother. Longsuffering.
Esther	The Grandmother. Dying.
Greg	Matthew 13:20-21
John	Dawn's ex-husband. Mitchell and Shore's Father. Their scapegoat?
Anderson	Another Character in Another Medium of Existence. Probably a Sociologist. Maybe an Anthropologist.
Planted Audience Member	

The Setting

The family's house. There is a door stage-right leading to Shore's room. There is a rectangular kitchen table right-of-center. There is a small platform with a door stage-left leading to Mitchell's room in the basement. There is another door further upstage leading to the living room, front door, & etc. There is sparse decoration. There are a few pictures on the walls, but in only one picture is the family all together.

The Prologue

(There is darkness. Mitchell enters, standing in the middle of the stage. A light comes on. He scans the audience, but he does so without scrutiny. He gives the audience a slight nod. He then twists his head around to get another good look at some of the people on the far side of the audience. He arches his eyebrows and offers a little wave. Then, in order to clear his mind, he shakes his head. He finally begins.)

Mitchell

(In good humor)
It's funny. The place from which I hail – I like that phrase quite a bit – uh – well, it's not the most wonderful of places, I guess you could say that. Anyway.
(He clears his throat and starts over) Coldwater is a small city located in Northern Ohio. It sits on the shores of Lake Erie and capitalizes on this location by focusing all of its energy on being a summer vacation destination for Midwesterners. It is conveniently placed between Toledo and Cleveland. Rumor has it that Coldwater would have been the largest city on Lake Erie if there hadn't been a series of cholera epidemics, with one striking especially bad in the year 1849. Although the people of the city created the municipal water system after the outbreaks, one might say that Coldwater did not recover quickly enough after the epidemics, and so other cities were able to race ahead of them and become the major centers of growth and

commerce in Northern Ohio. The city did, however, produce a theme park, the world-famous Strawberry Bank. But, even with this asset in the community, Coldwater has struggled with how to alleviate the rampant poverty that exists in the Rustbelt, which has existed there for a long time. But, oh, hey don't take my word for it. Take someone else's words.

 (He opens a book that is obviously not
 American Notes by Charles Dickens)
In his book, *American Notes*, Charles Dickens describes Coldwater as "sluggish and uninteresting enough...something like the back of an English watering-place, out of the season."

 (He closes the book and carelessly tosses
 it aside)
The point is: Coldwater has never really been known as a great place. In fact, as it stands now, the city is not able to offer very much in the way of respectable employment. There just aren't many good, dependable jobs available. There are plenty of restaurant chains and big-box stores, but these seem to offer little pay and too few opportunities for true advancement, and since there is not much else available, a good sum of the people whom I have known have had to settle into these jobs and rely on food stamps and W.I.C. to get from day-to-day, from month-to-month. Other friends of mine come up with what I would call "grand schemes" as solutions. These grand schemes usually don't pan out, but people like to think them up and talk about them. These range from playing the lottery everyday with some insane sort of strategy to drawing up plans to go homesteading in

Alaska, thinking that it'll be easy to go from living as a permanent member of the underclass in a small Midwestern city to living off of the land in harsher but more beautiful environment. A couple of my friends were actually preparing to go on that homesteading adventure - really, they were - but at the last moment, at the eleventh hour, they back out. Now they sell drugs - and, as it is for quite a number of people around here, now that's just simply their life and it probably will be their life until the end. Once you learn a trade, it's as though it's too late to back out and develop some other skill - even if that trade is learning how to move bags of weed and little pouches of cocaine. Of course, in the end, that skill might become pretty worthless - unless there's another miracle plan up one's sleeve somewhere. But...
 (Summing it all up with his utmost
 intelligence)
On the whole, things kinda suck a little bit.
 (He clears his throat and starts again)
It's a tiny place, and it's not hard to get sucked into its ever-tinier world, a microcosm in a microcosm of the macrocosm, Kind of like feeding a pig bacon-
 (He cuts himself short upon realizing
 that this last sentence didn't make much
 sense)
Uh-! Tiny, subtle, apparently insignificant things just washing ashore, one after another - routine succession...
 (He wonders where he was going with those
 last few thoughts. Feeling the pressure
 to move on, he waves his hands in the air
 as if to dismiss all of the nonsensical

> things that he has just said, and he
> clears his throat. He needs to move past
> all of the previous verbal wreckage.)

Thus, things continue on as they have always gone on. The times, they are a-changing – but not much else does. Coldwater, like everywhere else, is just composed of things. Small things here though.

> (He shrugs; he knows he has botched the
> Prologue)

These things, they happen. A lot of things happen, and as with Coldwater, most of them really aren't that significant to the world-at-large, but, in the end, for the pieces and parts that make up the foundation, they mean everything. Um, but, that's thinking kind of too big, and I obviously can't handle that right now. Buhhht-tut-tut-tut-tuhhh-yeah.

> (He claps his hands to put an end to his
> prattling on, and he smiles a presenter's
> smile)

Ok, right.

> (Knowing that he has nothing more to say,
> he decides to, in simple fashion, ramble
> off and exit, the end of his speech
> trailing behind him)

So – uh – yeah. That's how those things work and – so – uh – yeah – whatever, ok.

> (He has disappeared. The Planted
> Audience Member laughs. Blackout.)

End of the Prologue

Scene 1

(Lights. Mitchell is sitting at the kitchen table. Among other junk, there is a straw on the table. He is wearing an old, flannel coat but it is unbuttoned. He is building up a house of cards. Throughout the scene, he sniffles periodically. He has knocked over a glass of milk, but he has not bothered to clean it up. A few moments pass. Dawn enters from upstage. She has a basket of laundry in her hands.)

Dawn
(Walking to the table and setting down her basket of laundry. The house of cards collapses. Mitchell, though visibly upset, does not say anything; he starts over.)
Honestly, MitchELL, I thought I told you to throw away that nasty, old jacket. It's all tattered and stained to hell.

Mitchell
It's my coat.

Dawn
But it looks so awful, MitchELL.

Mitchell
It's a good coat.

Dawn
It's an ugly-looking coat.

Mitchell
It's a good coat.

Dawn
(Without agreement)
Yeah.

Mitchell
And quit saying my name. That isn't how you say my name.

Dawn
What? What's wrong with the way I say your name?

Mitchell
You're saying it wrong. That's what's wrong.

Dawn
Oh, that's rubbish.

Mitchell
No. The way that you're saying it, that's rubbish.

Dawn
Honestly, MitchELL, grow up.
 (Beat)

Mitchell
You're saying my name wrong – don't you understand that? It's my name, dammit!

Dawn
Ok, don't start getting all excited now. Please. We don't need to raise our voices in this house…
 (Beat)
You get so… Worked up. You're always so worked up, that's what's wrong. You're too worked up.

Mitchell
(Flatly)
How many times are you going to say "worked up"?

Dawn
Well, it's just that you are. You're worked up. And that's what's hurting you.

Mitchell
You've already said that. Are you just going to keep saying it again and again and again?

Dawn
I know, but I'm just restating the fact. That's all. I just don't want my son to be known as being "worked up."

Mitchell
(On the tail-end of her sentence)
And it's not a fact.

Dawn
It might as well be.

Mitchell
And what about you?

Dawn
Excuse me?

Mitchell
What's your part in all of this, huh? What about you? What if you're the one going around and getting everyone all worked up, hmm? I was doing fine all by myself until someone just came along and bothered me.

Dawn
See, you're getting all worked up again.

Mitchell
 (With a scoff)
Yeah - sure.

Dawn
What?
 (There is a pause)
What is it now?

Mitchell
What is what?

Dawn
What was that scoff all about?

Mitchell
 (Growing tired of the conversation)
Nothing. Nothing at all.
 (The doorbell rings)

Dawn
Could you answer the door?

Mitchell
Why? It's not going to be anybody at all anyway. Probably just a Mormon - or the Jehovah's Witnesses.

Dawn
Mitchell, could you please just get the door?

Mitchell
Fine.
 (He rises and exits upstage. He can be heard answering the door.)

No, we don't want any.
 (Beat)
Yes, I'm sure.
 (Beat)
Bye.
 (Mitchell enters from upstage and takes
 his seat. He resumes the exercise of
 building a house of cards.)
I told you. Nothing good comes of answering the door anymore.

Dawn
Thank you for getting the door regardless.

Mitchell
I told you that it was a waste of time. Next time, you can get it.

Dawn
MitchELL.

Mitchell
I told you. Quit saying my name.

Dawn
 (Rubbing her temples)
MitchELL, you're really working my nerves. If it's not one thing with you, it's another. Honestly…

Mitchell
…Well, what else do you expect it to be?

Dawn
See! This is what I'm trying to talk about. This - this - dreariness! It's - awful.
 (Mitchell scoffs)
What?
 (Mitchell doesn't answer)

What is it all about, huh? Well, what is it?
 (Mitchell remains silent)
I swear…
 (There is an extended pause)

Mitchell

Swear what?

Dawn

How should I know? You never tell me anything really. You try so hard to be miserable that it's almost, well, it's sickening. To watch my own son make himself miserable, to make himself sick. It's not…
 (Searching for the right word)
It's just not ethical.

Mitchell
 (Pouncing on the fact that she's used the wrong word and letting out a chuckle; in mock disbelief)
Ethical?

Dawn
 (She is so stung by this latest indignity that she accidentally knocks over the basket of laundry, spilling its contents out onto the floor and into a small puddle of milk)
Fine! That's it! You got it! You win!
 (Exiting upstage)
Now we're both miserable…
 (There is a pause)

Mitchell

So that's how you get rid of it.
 (By now, Mitchell has rebuilt the house of cards back up. Mitchell looks at it,

 hoping that it will stay. He blows at
 the house, testing it. It does not
 fall. Flatly.)
…Yippee…
 (There is a short pause. The house of
 cards falls down for no apparent reason.
 Mitchell contains his frustration. Then
 he reaches down and grabs a hidden bottle
 of scotch and a plastic cup from
 underneath the table. He fills half of
 the cup up with scotch and places the
 bottle of scotch back underneath the
 table. He toasts by himself.)
Move along there, please, Ladies and
Gentlemen, hurry along there, move along,
please…
 (He finishes the toast, takes a drink of
 the scotch, and pats his coat's beast
 pocket to reassure himself of its
 contents. He picks up the straw and
 places it into his breast pocket. He
 decides to take the bottle of scotch with
 him as he rises and exits stage-left.
 There is a pause. Anderson enters stage-
 right, wearing a lab coat and carrying a
 clipboard. He pauses in the middle of
 the kitchen, checks his notes, shakes his
 head, and laughs to himself. He makes a
 few additional notes. Blackout.)

End of Scene 1

Scene 2

(Lights. Esther is sitting near the edge of the stage. Since she is extremely elderly, she is in a great deal of chronic pain. Nevertheless, she is making a cat out of art supplies. In her room, Shore is playing music very loudly.)

Esther
(Putting the pieces together)
There… There we go. You're coming along quite nicely, wouldn't you say? Yeah… Yeah, you are.
(Leaning in tenderly)
I'm your mommy, and you're my kitty. I made you.
(Correcting herself)
Am making. I am your mother. …and your grandmother. I am also your best friend, and you are my kitty-cat. Yes. Yes, you are. You're coming along quite nicely.
(Playing a trick on the cat; pointing at his tiny chest)
What's that? What is that? Huh? What is that?
(Pause)
It's your fur!
(Stroking the cat lovingly)
You're such a happy cat. And a good cat.
(A piece of the cat falls off)
You're going to be such a happy cat… Yeah… You are. What a nice cat you'll be. You… Well…
(She stops, thinking of something)
Well… Hadn't [thought of]…
(She sets the cat down next to her and looks at the floor in front of her.

(There is a long pause. She starts to smile a bit. Shore enters from upstage in a fury. She looks down at Esther with contempt.)

Shore
What do you think you're doing?
 (Esther does not answer)
What the hell do you think you're doing?! I'm trying to clean – I've got to go to school tomorrow – and I'm never going to finish 'cause you're making a mess!
 (There is a long, silent pause. Shore marches up to Esther and, out of frustration, viciously stomps on her cat, just once. The stuffing flies out of the cat. After the cat has been annihilated, Shore exits stage-right. Esther lets her face fall into her hands; she is crying softly. Blackout.)

End of Scene 2

Scene 3

(Lights. The small pile of cat remains has been placed on the table. Esther's shoes are next to the platform. Mitchell is sitting at the table with an open bottle of beer, writing in a notebook. His coat is hanging on the back of his chair. He has more energy than usual, which seems strange; however, he is good at containing this burst of energy in front of other people. Shore is cleaning and listening to her music.)

Mitchell
You shouldn't be so mean to her, you know.
 (Slight pause)
She's old.

Shore
Shut up, Mitchell, I'm trying to clean.

Mitchell
You don't want to talk about that? Fine, let's talk about something else.
 (Beat)
You know, if it were up to me, I'd make sure they took away your license and kept you locked up with all of the other teenage criminals.
 (Pause)
You're lucky that I didn't tell Mom about those wine-coolers you've been hiding away in the basement.
 (Pause)
You know, a refrigerator is kind of an obvious place to hide things like that.

Shore

(Sharply)
That's nice.

Mitchell

You need to calm down. Relax a little bit.
 (Short pause)
You have a good way of building up the tension around here.
 (Short pause)
You're going to burn yourself out before you've even hit seventeen.
 (Short pause)
You've got no sense of humor.

Shore

I have to clean -- I have to go to school tomorrow! You don't have to do shit. You just sit around and mess up my house, Mitchell.

Mitchell

Quit using my name in every other sentence. And yeah… I make a *real* big mess. I've been using the same cup for about a week now - and it's plastic for Christ's sake!
 (There is an unnatural pause. Lowly,
 honestly)
How come we can't seem to have a normal conversation?

Shore

(Sharply)
I don't know.
 (He waits for a real answer, but she does
 not provide one. He spreads his hands
 out, signaling his desire for a real and
 honest answer to the question. There is
 a pause. She responds even more

sharply.)
I don't know, okay?
 (He is still waiting for an answer)
Leave me alone, Mitchell!
 (Beat)

Mitchell

 (Sharper and more disgusted than Shore)
Nevermind!

Shore

Mitchell! I'm tryin' to clean! I have to get all of this done! Go back down into your basement!

Mitchell

 (Rising to exit, grabbing his notebook and coat)
Fine. Whatever you want if you're going to be a total ass about it–
 (Simulation stops – Anderson has entered from stage-right. As he makes a note, an idea strikes him.)

Anderson

What would–
 (Suddenly pausing to give deeper thought to his idea)
I wonder…
 (There is a short pause. Anderson whispers into the motionless Mitchell's ear, knowing that the suggestion will be followed when the simulation resumes.)
Call her "Joan" for me… That ought to… Yeah.
 (Anderson exits upstage. Simulation resumes.)

Mitchell
-Joan.

Shore
(Throwing her cleaning supplies down and turning towards him, deeply wounded)
I'm not Joan!

Mitchell
(Moving towards the basement)
Yeah… Whatever – Joan.
(As he is exiting, with disgust, motioning towards the beer that he left on the table)
I don't even want that anymore.
(Mitchell exits stage-left. Shore turns away, perhaps to cry. Blackout.)

End of Scene 3

Scene 4

(Lights. The pile of cat remains has been placed on the floor near the far wall of the room; it seems a little larger than before. Dawn has a basket of laundry on the table. Mitchell enters from the upstage door. He has just come in from the rain. His coat and work clothes are soaked. Mitchell takes the straw out of his pocket and throws it away without Dawn noticing.)

Mitchell
(Taking off his coat and holding it in his hands)
I'm back.

Dawn
(Without looking at him, with genuine happiness)
Good, I'm glad.

Mitchell
Yeah - *thanks.*

Dawn
I was just worried about you…

Mitchell
I was at work!

Dawn
I was just checking up on you…

Mitchell
I was at work! You don't need to come check up on me when I'm at work! You're the one that insisted that I get a job, and then you

have to go and make me look like a stupid-ass little child by coming in to "check up" on me.

Dawn
I only did it because I was worried about you.

Mitchell
Well, why don't you worry about me looking like a fool for a change? That'd be a nice thing.
 (With a sharp edge)
That'd be damn swell.

Dawn
I didn't do it because it was nice; I did it because I love you.

Mitchell
Yeah. Right.

Dawn
I always put my children first.
 (There is a brief pause)
I love you, MitchELL.

Mitchell
Then how about thinking before you go and do something? Is that really so much to ask? Now they're going to treat me like a child.

Dawn
No they won't.

Mitchell
Yes they will. All because you had to go and make me look like I was some asshole stuck in junior high. Good job. You really

let some "love" shine through on that one.

Dawn

MitchELL-

Mitchell
(Cutting her off)
No.

Dawn

You have to understand. I-
 (Invisible to both Dawn and Mitchell, Anderson has entered upstage and has clasped his hand over Dawn's mouth so that she cannot be heard. She is still speaking, but no one can hear her words. Mitchell takes off his work shirt, carelessly tosses it into the laundry basket, throws some change on the table, and starts to exit stage-left.)

Mitchell
(Coldly)
There's some extra change for milk.
 (He exits stage-left. Anderson removes his hand; Dawn has stopped speaking. Dawn looks down at the laundry basket. She picks up the work shirt, holds it out, gently wipes it as though to remove the wrinkles or a few specks of dirt, and looks at the shirt with a sad smile. Anderson makes a note. Blackout.)

End of Scene 4

Scene 5

(Lights. The pile of cat remains seems larger than before. Esther is sitting in the kitchen with a cup of coffee, which she remains focused on throughout the scene. Dawn is taking a basket of laundry out of the room.)

Esther
Oh boy, those women drove me up the wall today. They had me running here and running there. I was everywhere. I just had to keep telling them, "No." But they don't listen. That's why they're in there.

Dawn
 (Exiting upstage)
Uh-huh.

Esther
 (As though Dawn has not exited)
But I stuck to my guns. I didn't let them have their way. I just had to keep telling them, "No." That's why they're in there. Because they don't listen. They got on drugs and alcohol, and they ruined their lives. Well. That's what they wanted to do.
 (Shore enters from upstage and throws a
 tissue away)
I was just telling your mother-
 (Shore exits upstage. Esther pauses.)
Now what was I telling your mother…?
 (As though Shore has not exited)
Oh! I was just telling her that those women in there are the way they are because they got on drugs and alcohol. They wouldn't let anyone tell them, "No." But I tell them,

"No." I have to. That's my job. If I didn't tell them, "No," then who would? We had one fail a testing just last week. ...Don't you ever get on drugs or alcohol. You might end up in there. With all those women. And then they'll drive you up the wall. They drive me up the wall – everyday! Having me run here and there and everywhere! You just have to tell them, "No." If they had heard that a little more often, they wouldn't be in there.
 (Mitchell enters, bare-chested, from stage-left with an open beer and two empty cans. His manner is more light-hearted than usual. He places the two empty cans in the trash.)
I was just telling your mother and sister about those women. Oh boy, today, they were driving me up the wall. They had me running–

Mitchell
 (Interrupting and finishing her sentence for her)
Here and there and everywhere?

Esther
Yeah, and I just kept having to tell them–

Mitchell
 (Interrupting and finishing her sentence for her)
"No."

Esther
Yeah–

Mitchell
(Interrupting her and exiting stage-left)
And if they really listened to you then why do you have to keep on telling them no?

Esther
Well… Because… I hadn't [thought of]… They were running me up the wall… And… "No…" They were just… From the drugs and alcohol… So… They… Need to be told, "No…" And… They listened.
(There is a long pause. Meekly, looking up from her coffee)
Why wouldn't they…?

Anderson
(Hidden from view; in an honest voice)
Well, why bother?
(Blackout)

End of Scene 5

Scene 6

(Lights. The pile of cat remains seems to be larger. Mitchell is at the kitchen table, resting his head after a long day of work. His coat and work apron are draped over the table. Shore is folding clothes at the other end of the table, occasionally throwing a contemptuous glance at Mitchell's belongings on the table, and listening to her music once again. They exist, with the exception of the music, in silence, each not acknowledging the existence of the other, with the exception of Shore's mean looks of course. Anderson appears. He studies Shore and makes a checkmark on his clipboard. He disappears, patting Shore on the back as he does so; she does not feel his touch. After a moment or two has passed, Mitchell belches. Shore's reaction is almost immediate.)

Shore
Damn it! You're ------- gross!

Mitchell
(An attempt at humor with a sharp edge) *Young ladies shouldn't speak like that.*
(There is a pause)
Oh, and just as a note, I know what you're thinking - and no - I'm not drunk. I haven't even been drinking; who has time to drink when they have a job? …Not to mention that this job is complete bullshit. It's stacking and scanning stuff - that's it - no more, no less. It's like playing with

building blocks and then putting them back in the toy chest over and over, all day long. There's nothing work-progressive about it. Those people don't even need half of the shit that they buy anyway! Foodstamps to get three candy bars and two liters of ------- Faygo. A can of yams and four gallons of ice cream to feed one father and four pudgy children. Or how about the woman that tries to buy Doritos for two dollars but they're actually three dollars and who can't afford them so she throws a bottle of dish soap at me as though it's my fault? These people are crazy. I mean really flat-out nuts.

> (He notices that Shore has been ignoring him; with some bite)

Yeah, you just keep on cleaning away; don't mind me. Just… Nevermind.

> (He makes an awkward gesture, somewhat like the gesture that we might expect from one of Shore's favorite music artists, an obviously and cliché mockery. They return to their usual state of co-existence. There is a long and drawn-out pause. After the pause, Dawn enters upstage, wearing an out-of-fashion dress in what could be seen as a naïve but endearing and lovable attempt to appear fancy. Following shortly behind her is Greg, a man slightly older than Dawn. He has a presence like radiant light, and he is also, ironically, a born-again Christian. His t-shirt has a large, white cross protruding out of a jagged, black hole. At his entrance, Shore and Mitchell are subtly shocked out of their usual state of co-existence.)

Dawn
(Smiling and hiding most of her
nervousness)
MitchELL – Shore – I'd like you to meet
Greg.

Mitchell
Greg?

Greg
(Offering a handshake)
It's good to meet you, brothar.

Mitchell
...the hell?
(To Dawn)
Are you adopting now?

Dawn
Well... Greg and I are... seeing each other,
but... only if it's alright with my children.
(As though stating a philosophy)
My children always come first.
(Shore has finished folding the clothes
and begins to exit upstage)

Shore
(As she is leaving; directed at Greg
without looking at him; flatly)
Good luck.
(Shore exits upstage. There is a short
pause, exposing more of Dawn's anxiety.
Being a man of conviction, Greg is only
slightly shaken by what he can only see
as a minor and temporary setback.)

Mitchell
(Dryly; to himself – mostly out of lingering shock)
I need a drink.

Greg
Aw, man – Mitchell, you shouldn't drink. It's not good for you. I used to drink, but – nah – not no-more. Nope, no-sir-ee!
(Slower)
It's just not good for you, brothar.
(Mitchell blankly stares at him. After a short period of time, Mitchell rises, walks to the stage-left door, opens it, and turns towards Dawn and Greg.)

Mitchell
(In a moment that is different for him)
Look. You don't want to be here. Trust me.
(Mitchell turns and exits stage-left. Dawn is visibly shaken. Greg, knowing her reaction, offers some comfort.)

Greg
There. That wasn't so bad.
(There is no change)
Aw, relax, honey. They'll come around.
(He chuckles a bit to lighten the mood, and with sincerity, he smiles at her)
And of course I want to be here. Why not?
(Beat)
It'll be fine. Trust me.
(Slowly)
It'll be fine.
(Dawn, being slightly comforted, forces a small smile. Blackout. Anderson groans in the darkness.)

End of Scene 6

Scene 7

(Lights. The pile of cat remains has become somewhat scattered. Esther is sitting alone at the table, eating cereal with no milk out of a paper bowl.)

Esther
(Talking to the Mickey Mouse print inside the bowl and coaxing herself into a willful suspension of disbelief)
They're so mean to me, sometimes… I don't understand why… But you understand, Mickey. You and I are like best friends… I know that you won't ever leave me. You're there to keep me company… when no one else will. That's because we're good friends… We can do anything together. What do you want to do?
(There is an incredible pause)
You're such a good listener. The other day… The other day, I had a cat. Yeah… He had fur, and everything. And he was a good kitty… But he got stomped... But you won't get stomped like that kitty. He was a good kitty. He drank milk. But you aren't going anywhere - because we're the best of friends… You and me… We've been friends for a long time… Such a long time, Mickey… You've never let me down… And you always listen… When I've needed you, you've never left me… Alone… Never… Because you're such a good person… or… Mouse… My favorite mouse… I knew you'd find that interesting. You always find everything interesting. All of it… And that's why you'll never leave me… Because we're the closest of friends… Best friends… You and

me… Mickey… You and me… No friend could ever appreciate another person like you appreciate me… Nobody. You're… Really… Good.
 (As though she were making a bold move)
…I love you, friend…
 (There is a long, silent pause)
…And I know that you love me too…
 (There is another pause; very softly)
…even if you can't say it back…
 (There is a short pause; then – softly)
…We should just go away together…
 (Anderson laughs in the distance.
 Blackout.)

End of Scene 7

Scene 8

(Lights. Anderson is standing in the middle of the room. The scattered pile of cat remains seems to have been significantly reduced. Anderson makes a note, and then he leaves the room. Dawn and Greg are having tea.)

Greg
Personally - I think they'll come around.
 (As though providing a solution)
Time. It's the answer to all things.

Dawn
I've always put my children first. John wasn't able to do that, but I did. He just picked up and left one day. Took off for only God knows where. But I stuck to it.

Greg
Well, then what's the problem?

Dawn
MitchELL's all upset because you were talking to Shore about her cleaning habits the other day. He said that he didn't appreciate "Gregers" lecturing her like that.

Greg
I wasn't lecturing her at all; I was just trying to tell her that there's more to life, you know. It's just not right - her cleaning all day. She needs to get out, do other things. As it is, it's no good. It's just no good.
 (There is a brief pause)
I was only trying to help.

> (Politely chuckling)
> Trust me, lecturing is the last thing I want to do.

Dawn
That's not what MitchELL seems to think.

Greg
Well, what does Shore think?

Dawn
She said she doesn't care, but -
> (She hesitates for a second)
> I don't know. I just don't know.

Greg
Well, then there's no problem, right?

Dawn
Yeah-
> (She hesitates again)
> But what about MitchELL?

Greg
Nah - Don't worry about it. I'll talk to him. I'll make sure he's alright. Come on. Trust me.
> (Dawn still looks worried)
> Look, Mitchell, he ain't never been a father. He doesn't know what it's like. You said it yourself, he hasn't had one. He's gone his whole life without a father. He's his own father, teaching himself to shave and whatnot. That's not ideal, and so it's hard for him to know what to do. He just doesn't know. But he'll come around. He'll get used to it. One day, all of a sudden, it'll just start happening. He'll start getting it. He'll see that

everything's going to be alright. That everything is going to be fine. He'll like that. One day, he'll just be sitting there, and it'll dawn on him, "Ah, this is what peace is like." He'll be at peace.
 (Rubbing her back)
He just needs some time. He'll feel better once he gets used to things.

Dawn

I don't know.

Greg

 (Taking her hand and holding it gently)
I told you everything would be fine, and I meant it. We'll just have to work at it. That's all. We'll just work at it.
 (There is a pause)
Look, if it makes you feel any better, I'll be really good about not overstepping my boundaries. I'll give it some distance for a while.

Dawn

Alright. I just don't know sometimes, that's all. It all seems-
 (She swirls her hands around to
 demonstrate her point)
-to just build up and go out of control.

Greg

 (Smiling at her)
We can fix that. Trust me. Shoot. Ain't nothing we can't do.
 (Dawn smiles at him. She brightens up.
 Their handhold becomes more tender.
 Blackout.)

End of Scene 8

Scene 9

(Lights. The pile of cat remains has reformed, compacted; yet, it is larger than before. Esther is seated at the kitchen table; she is staring down at the tabletop, sitting motionless. In her hands, underneath the table, unseen, she is holding the bowl with Mickey Mouse printed on the inside. The bowl is empty now. Mitchell enters from the stage-left door, which leads to the basement. He is wearing his coat over his work clothes. He looks around, seeing that only Esther is present.)

Mitchell

I'm going to work.

(Mitchell exits upstage. There is a significant pause. Esther lifts up her head. Slowly, very slowly, she rises, still holding the bowl in her hands. She walks very, very slowly. She is very old and in a great deal of pain. She walks towards stage-left, where the trash can is located. She very, very slowly makes her way towards the trash can, still carrying the bowl. When she is halfway to the trash can, she accidentally lets the bowl slide out of her grasp. Very, very slowly, with great care, she bends over to pick up the bowl. When she has finally bent over and grasped the bowl once more, there is a pause. One wonders whether she will be able to straighten herself back up. The situation is worrisome. Slowly, very slowly, she

starts to straighten herself back up. It takes a great amount of effort on her part. When she has finally straightened herself back up, she pauses to catch her breath. She is very old. She moves towards the trash can again, very slowly. When she finally reaches the trash can, she drops the bowl inside. Then, surprisingly, she keeps going, sluggishly moving towards stage-left. It slowly becomes apparent that she is heading for the stage-left door. With sustained amounts of great effort, she makes her way towards the door to the basement. When she finally reaches the door, she opens it, holds her head up high, and stiffly throws herself down the stairs. There is no scream, only the sound of a tumbling body. There is a long pause after her body hits the basement floor. Anderson cackles. Blackout.)

End of Scene 9

Scene 10

(Lights. The compacted pile of cat remains is much larger now. Everyone is still dressed up after the funeral. Mitchell is sitting at the table, trying to build a house of cards but the structure keeps collapsing before he gets very far. Over his dress clothes, he is wearing his ugly, old coat. It appears to be dirtier now. Shore is sweeping the floor. She is pushing the pile of cat remains into itself, yet it is as though she cannot really see the cat remains. She just keeps sweeping the pile together. Dawn stands with a cup of tea, blowing on it to try to cool it down, and stares blankly at nothing in particular. The scene remains this way for quite some time.)

Mitchell
It was nice.

Dawn
Yes, it was.

Mitchell
Pastor Daniel's sermon was very well-done.
 (No one responds)
He was okay for a pastor.
 (There is a very, very long pause)
I-
 (There is a pause)
-uh-
 (There is a pause. Dawn looks up from her tea at him.)
I just thought I was going to work...

Dawn

MitchELL-

Mitchell
(Interrupting her)
Nevermind. I can't do this.
 (He rises and begins to head stage-left, but he quickly changes his mind and moves to exit upstage)
It's just- Nevermind.
 (He exits upstage)

Dawn
(To herself)
My goodness...
 (There is another long pause. Dawn blows on her tea one last time and takes a sip. She remarks on her tea somewhat flatly.)
This is awful.
 (There is yet another long pause)

Shore
(Gentler than ever before)
Did someone clean the stairs yet?
 (Dawn does not respond; instead, she just continues to stare blankly at nothing in particular. Shore simply continues sweeping. Anderson enters from stage-left, from the basement. He is carrying Esther's shoes. He tosses the shoes into the pile of cat remains. He makes a note on his clipboard. He looks at Shore, examining her. Then he looks at Dawn, examining her. He makes another note. He exits upstage. There is a final long pause. Blackout.)

End of Scene 10

Scene 11

(Lights. The pile of cat remains is still compacted, but it is larger and now garbage has been strewn about inside of it as well. Mitchell, wearing his work clothes, is eating a peanut butter sandwich at the table. A few moments pass. Without warning, the doorbell rings. Mitchell does not respond. A moment passes. The doorbell rings again.)

Mitchell
(While still chewing)
Come in!
(The front door can be heard opening and closing. A moment passes. John enters from upstage. Mitchell is confused. John, who has mastered the art of hiding his own nervousness, is wearing an old, worn out black suit and a forced ear-to-ear smile. He does not realize that his old, faded suit is not truly good-looking.)

John
Hey...

Mitchell
(Still confused; a little worried)
Do I know you?

John
No, not really, but let me explain.
(Mitchell looks at him questioningly)
You- You don't know me, but, umm.

Mitchell
(Sensing where this might be going)
No.

John
Mitch, listen-

Mitchell
(Coldly; pointing towards the upstage door)
No.

John
What's the mat-?

Mitchell
(Dropping his sandwich and rising)
No. Sorry, but nope. Nope.

John
Mit-

Mitchell
Out. Please. Out.

John
Just listen.

Mitchell
No, not now. I'm sorry. No.

John
Mitch, don't be childish.

Mitchell
(On the tail-end of John's line)
No. What did you expect?
(John is stung)
Were you around to pay for college? Where

were you? Are you married? Was I invited to the wedding? What about a message? Maybe a call? Or a letter? What about a letter?
 (More direct)
But just showing up here? No, it's too much. Please. It's too much. Not here, not now. Go. I don't know why, or just can't say, but go. Please. Go. Out.

John

Mitch, life is a tricky thing.

Mitchell

 (Incredulous)
A tricky thing?

John

 (Explaining as best he can)
The older you get, the less sure you get about things, the less you find you really know about them.

Mitchell

Then allow me to make it simple. Out. Your life, it's out there somewhere.

John

Mitch, first off, I'm your *father*. Second, if you'd just hear me out, then you'd know what it's been like "out there." You'd understand why it is that I've been somewhere out there.

Mitchell

Understand? If you want understanding, go see the clergy. But me? I don't want to understand. I-

John

Mitch, I've been dealing with things that I can barely-

Mitchell

That's not my name.

John

(Confused)
You're not-?

Mitchell

No, it's Mitchell. Mitchell. That's my name. Get my ------- name right.

John

(Becoming frustrated finally)
Aren't you being unreasonable?

Mitchell

How about you tell me what reasonable is. Please set down for me the definition of reasonable. I would love to know what reasonable means.

John

You have no idea how hard this is!

Mitchell

Oh, I think I do! I'm pretty sure I do!

John

No, Mitchell, it's not the same! It's different!

Mitchell

Oh yeah? And why is that?

John

(From angry frustration to the verge of tears)

Because you're not the one who's at fault! I am!

(There is a pause. John has left himself wide-open, and Mitchell is unsure as to how a person handles such a situation. Both men are out of their depth; both of them are in new emotional and relational territory.)

Mitchell

I - uh -

John

Please. Let's just talk. Give me chance to try to-

(He doesn't know how to put it)

-Just let me tell you a little bit about me, about my life, about who I am.

(Motioning towards Mitchell)

And let me find out who you are. And, afterwards, if you don't want to see me ever again, fine. Just give me a chance.

(Mitchell sits down at the table. John pulls out a chair and sits down at the table with him. Though we can see that John has started sharing his life story, we are unable to hear any of the words. Anderson enters through one door, makes a note, nods his head approvingly, and exits through another door. Blackout.)

End of Scene 11

Scene 12

(Lights. Someone has draped a sheet over the big pile of cat remains and garbage. Dawn is in the kitchen, folding laundry. Jazz music plays from a radio that she has brought with her into the kitchen. A moment passes. Mitchell enters from upstage. He is wearing his old coat and smiling. The coat looks much cleaner now. He is carrying a bag with a shoe box in it.)

Mitchell
Hey, mom.

Dawn
Hey, where have you been?

Mitchell
Out with dad. We had lunch, talked, and then we walked around the mall for a bit. He got me some new shoes, slip-resistant ones for work.

Dawn
 (Frowning slightly)
That's good. I'm glad that you had a good time with your father.

Mitchell
Yeah, it was great. Really. I mean – the guy's not perfect, but once you really get to know him, he's not so bad.

Dawn
Oh yeah?

Mitchell

Yeah, I mean, you know, the struggle with alcohol and drugs, the years of wandering around, not really being at home anywhere. Even the experience of sleeping in a shelter in Seattle, but to come out of it, to really know yourself and step outside of your problems, perhaps it was all really worthwhile.

Dawn

That's good, MitchELL; I'm glad that you're getting to know your father...

Mitchell

I think-
 (He pauses)
I think I've really needed this.

Dawn

I'm glad that it happened for you.

Mitchell

Yeah, me too.
 (Suddenly becoming aware of time)
What time is it?

Dawn

A little after 3.

Mitchell

 (Searching around for his work clothes)
Ah, shoot. Yeah, I've got to be at work in less than an hour. Have you seen my work clothes?

Dawn
(Pulling the clothes out of the basket and handing them to Mitchell)
Here, clean and fresh and everything.

Mitchell
Great! Thanks!
(The doorbell rings)
That's the door! I'll get it!
(Mitchell exits upstage. He can be heard answering the door. He is somewhat disappointed.)
Oh, hey Gregers.

Greg
(From offstage)
How's it going, brothar?

Mitchell
(Flatly)
Fine. And you?

Greg
Great! It's a good day to be alive. The Lord woke me up and everything. Kept me breathing. Gave me the gift of another day.

Mitchell
Uh-huh.

Greg
Every day's a gift, Mitchell. Don't you ever forget that. Every single day is a gift.

Mitchell
(Entering from upstage with Greg following closely behind him)
Yeah, I'm sure.

Greg
(Walking up to Dawn and planting a kiss on her check)
And how're you sweetheart?

Dawn
Fine. Finishing the laundry. Are we still going out?

Greg
Of course, up, out, and away. We're going to take off. Wait till you see where I'm taking you tonight. One of the finest places you've ever been. I guarantee it.

Mitchell
Great, well, I'm going to change and get going.

Greg
Oh, you want a ride there real quick, Mitchell?

Mitchell
No, I can get there myself. Have fun.

Greg
Alright, you have a good night now, Mitchell, okay?

Mitchell
Yeah, I'm sure it'll be fantastic, one of the finest nights I'm sure I'll ever have.
 (Mitchell begins exiting stage-left)

Greg
Alright, take care now.
 (To Dawn)
You ready, honey?

Dawn

Yeah, I'm just about finished here.

Greg

Ah, good.

Dawn

(Pausing; concerned)
Do you think he's going to be okay?

Greg

(Chuckling)
What do you mean?

Dawn

He's just... I don't know. Things are different. Which is good, I guess... But, I wonder, I mean, it's all so new, so different.

Greg

Aw, he's just finally coming around. It's a good thing! It's good! Don't worry about him. He'll be fine.

Dawn

Yeah, I-
 (She lets out one, sharp laugh at herself)
I worry about things way too much.

Greg

Yes, yes you do. But hey! That's okay, honey. It'll all be fine. What did I tell you, huh? What did I tell you?

Dawn

(Lightly smiling)
That everything would be fine.

Greg

And?

Dawn
(Still lightly smiling)
Everything's fine.

(Blackout. Anderson groans in the darkness.)

End of Scene 12

Scene 13

(Lights. The pile of cat remains and garbage is still under a sheet, but it is definitely larger now and the sheet is beginning to rot. Mitchell is sitting at the dining room table. He has a phone in his hand. His coat is laying on the table. He is waiting anxiously. He taps the phone on the table a couple of times and then sets it down. He looks around for something to do, but he doesn't notice anything of interest. He stands up and exits stage-left. He can be heard descending the stairs. A moment passes. He can be heard ascending the stairs. He enters stage-left, carrying his deck of cards. He sits down at the table again, takes out the cards, and shuffles them. After shuffling the cards for a while, he begins building a house of cards. At first, he is successful, but as the house gets larger, it finally falls down on itself. Mitchell sighs. He picks up the phone again and looks at it. He sets it down and then slides it away. He stands up and finds the necessary items for making a peanut butter sandwich. He brings all of the items back to the table with him, sits down, and begins making himself a sandwich. Dawn can be heard entering through the front door. She enters upstage.)

Mitchell
Hey, where have you been?

Dawn
Oh. Uh- Greg's been showing me around Cleveland again. There's really quite a lot to see. He really loves that place. I had always thought that Cleveland wasn't much of a city, but… It's funny. It's like his love for the city is contagious or something.

Mitchell
That's nice.
 (There is a pause)
Hey, and uh… Where is Shore? I feel like I haven't seen her in a long time. I was wondering where everyone had gone, and so I peaked inside of her room to see if she was there and it felt so empty inside.

Dawn
 (Concerned by his question)
You do know that she moved out, right?

Mitchell
What?

Dawn
Yeah, she moved in with her boyfriend, Steve.

Mitchell
Steve?

Dawn
Yeah, she moved in with Steve a couple months ago, not long after Grandma's funeral… I think she was just sad.

Mitchell
Wow, I can't believe she moved out.

Dawn
(More concerned than accusatory)
How did you not know? She's your sister. How could you not notice?
 (Mitchell shrugs)

Mitchell
I must have been at work or something. I don't know.

Dawn
Or maybe you were just out with your father...
 (There is a pause)
How is your father?
 (Mitchell doesn't answer right away)

Mitchell
...I don't know. Not sure.
 (He pauses)
I haven't heard from him in a while.
 (He pauses)
I mean, I've left him messages and everything. Maybe he's just been tied up lately. Busy settling in or something. I mean, it's been a while since he's been back to Ohio and everything.

Dawn
No, it's okay. I'm sure John will get back to you soon. It'll be okay.

Mitchell
Yeah, he'll let me know.
 (There is a pause)
Okay, well.
 (He releases a deep breath)
I'm going to find something to do.

Dawn
Ok, sounds good. Have fun, dear.

Mitchell
Yeah...
 (Beat)
Thanks.
 (Mitchell exits stage-left. Dawn goes to the table. She starts to clean up, gather, and tidy Mitchell's space and things, but partway through, she decides to just leave everything for him to do later. She wipes off her hands, looks around the kitchen, nods approvingly, and exits upstage. Anderson enters from stage-right; he looks around the kitchen, nods approvingly, and exits upstage as well. Blackout.)

End of Scene 13

Scene 14

(Lights. Because most of the sheet has rotted through, the pile of cat remains and garbage is uncovered. It is gigantic, the largest that it has ever been. It is now frightful and foreboding. Next to the table, there is a large basket which is full of dirty laundry. On the table, there are four empty beer bottles, a pen, a pad of paper, the phone, a half-gallon of milk, and a straw that has been shortened. Mitchell, looking worn and weary, is sitting at the table, drinking a beer. He is wearing the old, worn-out coat. He has it buttoned up all the way. It looks dirty once again, very dirty. Anderson lingers at some distance, immobile but with his hand poised to make serious notes should the opportunity arise. A few moments pass. The phone rings. Mitchell answers it.)

Mitchell
Hello?

Dawn's Voice
Mitchell?

Mitchell
Where are you?

Dawn's Voice
I'm sorry. I didn't mean to worry you, honey. Greg and I just decided to go to Cleveland for the day. I should have told you, but I just wasn't thinking.

Greg's Voice
(In the background)
Here. Let me talk to him.
 (Mitchell rubs his temples)

Dawn's Voice
Here. Greg wants to talk to you, okay?
 (There is a pause)
Mitchell?

Mitchell
What?

Dawn's Voice
Okay?

Mitchell
Yeah, sure.

Dawn's Voice
Here's Greg.
 (Dawn can be heard handing the phone to Greg)

Greg's Voice
You there, brothar?

Mitchell
Yeah.

Greg's Voice
I just want you to know that I'm taking good care of your mother-

Dawn's Voice
(In the background)
And let him know that we'll be home a little late.

Greg's Voice
-and we'll be home in a few hours, okay?

Mitchell
Yeah.

Greg's Voice
I didn't think we'd be gone this long.
 (There is an awkward pause)
Everything alright?

Mitchell
 (Taking a sip of his beer)
Yep.

Greg's Voice
Well...
 (There is a short pause)
We'll be home in a few hours, brothar. So you take it easy, and we'll see you soon, okay?
 (Greg can be heard handing the phone back to Dawn)

Dawn's Voice
We'll come back later, Mitchell. Alright?

Mitchell
Alright.
 (There is a short pause)
I brought a half-gallon of milk home.

Dawn's Voice
What?

Mitchell
I bought some milk and brought it home.

Dawn's Voice
Oh. I thought that we already had milk.

Mitchell
Well, there's more here now.

Dawn's Voice
Oh, that's nice, honey. Good for you.

Greg's Voice
 (In the background)
We're almost to that place I wanted to show you.

Dawn's Voice
 (To Greg)
Okay, just one moment.
 (To Mitchell)
Honey, I've got to go now. I love you.

Mitchell
Love you too.

Dawn's Voice
Goodbye.
 (Holding the phone away from her ear now;
 more distant)
Now how do I hang up?

Mitchell
 (To himself)
Bye.

Greg's Voice
 (In the background)
Don't worry. He'll be fine.

Dawn's Voice
(A little more distant now)
Is this it?
(Dawn hangs up. A moment passes. Mitchell hangs up)

Mitchell
(Mitchell rubs his face. A long moment passes. The house is silent. Mitchell finishes his beer and rests his head on the table. Another long moment passes. His hand retrieves another beer from underneath the table. He opens the beer, rests his head on the back of the chair, and takes a big drink. A few long moments pass while he is drinking. Then he mumbles, almost inaudibly, to himself.)
...---- it.
(He picks up the already-shortened straw and looks at it. Then he pulls a small plastic pouch out of his coat pocket, holding it and the short straw in one hand.)
You've got to do what you've got to do...
(The lights fade to black. The appropriate music plays. After a few moments, the lights rise. An old family portrait of Esther, Dawn, Mitchell, and Shore is sitting on the table for the entire audience to see. In the picture, everyone is smiling, yet the glass inside the frame is broken. Anderson has appeared behind the audience members. He is wearing a coat exactly like Mitchell's coat. He is making notes about the audience. There is no curtain call.)

The End

ABOUT THE AUTHOR

www.ingramcontent.com/pod-product-compliance
Lightning Source LLC
Chambersburg PA
CBHW030912180526
45163CB00004B/1806